Joanne Lukitsh

JULIA MARGARET CAMERON 55

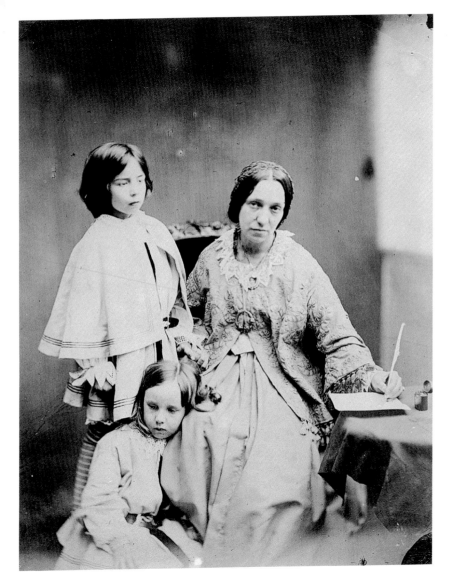

Julia Margaret Cameron is amongst the pre-eminent artistic photographers of the nineteenth century. Her photographic portraits and tableaux vivants, produced in the 1860s and 1870s within the most important artistic circles in Victorian England, have enjoyed almost continuous popularity for over a century. Cameron disdained what she called the 'mere topographic photography' common to contemporary commercial portraiture, favouring a more imaginative use of light and focus. Aspiring to high art, she looked to the old masters for inspiration. Her contemporaries saw reflected in Cameron's photographs the mid-Victorian belief in heroes, and the enthusiasm of the Pre-Raphaelite and Aesthetic Movements for beauty. Late nineteenth-century Pictorialist photographers claimed her as a precursor in their effort to secure acceptance for photography as an expressive art. More recently, Cameron's prints have prompted reflection upon photography's capacities for narrative and fantasy, and women artists and critics have revisited the sensuality of her images of children. Cameron's brilliant and imaginative transformation of conventional photographic lighting and focus stand as a major accomplishment in artistic photography, while her exploration of the communicative power of the human face in both portraiture and narrative images provides a touchstone for the examination of the broad impact of photography in modern culture.

Julia Pattle was born in 1815 in India. Her parents were James Pattle, an official of the East India Company, and Adeline de l'Etang, the daughter of an officer of the French infantry posted at Pondicherry. Members of both sides of her family had long histories of colonial service in India. Julia and her five sisters (one of whom died in early adulthood) were educated in France (with her maternal grandmother) and England, returning to Calcutta as young women. In the late 1840s and early 1850s, the Governor-General of India acknowledged the Pattle

sisters' vivid and original personalities when he divided mankind into 'men women, and Pattles'. Julia and her sisters remained close as adults (reportedly talking in Hindustani when among themselves) and their families frequently visited each other.

Julia met her future husband, Charles Hay Cameron, while visiting Cape Town, South Africa in 1836–7. On the same visit, she also met the distinguished scientist John Herschel, who was conducting an astronomical survey of the southern hemisphere, and his wife, Margaret. Julia and Charles were married in Calcutta in December, 1838. Charles, a widower, was a distinguished Benthamite jurist, who sat on the Indian Law Commission and was first legal member of the Supreme Council of India. The couple were leading figures in the colonial society of Calcutta, where they lived with their growing family until 1846, when Charles retired and the family moved to a home outside London. The family income was largely based on the Cameron family tea estates in Ceylon (now Sri Lanka), where Charles was one of the largest private landowners. In England, Julia Cameron began important friendships with poet and essayist Henry Taylor and his wife, Alice, and with Alfred and Emily Tennyson. Tennyson had recently published the elegies *In Memoriam* to extraordinary acclaim, and in 1850 both he and Taylor were under consideration for appointment as Poet Laureate, a position finally awarded to Tennyson. In the same year, Cameron's younger sister, Sara Pattle Prinsep, moved with her family into Little Holland House, the dower house of the famous Holland House in Kensington. Joining them was painter George Watts, who became the cherished 'artist in residence' at Little Holland House and its famous Sunday salons. Watts' ideas about the high purpose of art were crucial to Cameron, and he became her artistic adviser. She was, in the words of Pre-Raphaelite painter William Holman Hunt, 'most perseveringly

demonstrative in the disposition to cultivate the society of men of letters and of art'. Sara's salon at Little Holland House, with its unusually wide range of cultural figures, enabled Cameron to meet many of these men, several of whom would later sit for a portrait or publish a favourable review of her work. While Cameron, in the words of Alice Taylor, had a gift for loving others and forgetting herself, she was nevertheless a strong and determined person, who acted upon her own interests and those of the people she loved with a drive that nearly, but never quite, transgressed the proprieties of Victorian decorum. Cameron, by all accounts, worshipped Henry Taylor. She was his amanuensis, he her most photographed male model, and the two maintained an almost daily correspondence. Cameron was close to both Alfred and Emily Tennyson, but the latter would often leave photographer and poet together, declining to be the third party in their intense conversations.

In the late 1850s, a few years before she began taking photographs, Cameron herself posed for an unusual portrait by an unknown photographer. Her two youngest sons, Charles and Henry, stand and sit respectively at their mother's side. Neither boy looks at the camera, nor at Cameron for that matter, but she is in physical contact with both. She holds her older son Charles' hand on her lap, where Henry's hair falls as he leans against her. At her other side she leans on a small table, with pen, paper and ink at hand. These are the traditional attributes for a portrait of a writer – Cameron was a minor translator and poet, author of an unpublished novel, now lost, and a prolific correspondent with Taylor and others. Her expression in the portrait is thoughtful, her head slightly jutting forward, as if to emphasize intellect. The portrait is a performance – Cameron as mother and writer – revealing her understanding even then of the possibilities of invention in front of the camera.

By 1860, Cameron had moved her family to a home called Dimbola after their estates in Ceylon, next to the Tennyson estate, Farringford, at Freshwater, Isle of Wight. This home is strongly associated with her photography, which she began in earnest in January 1864. She had been interested in photography before this date, apparently making prints of negatives taken by another photographer, possibly the portraitist and fine-art photographer Oscar Rejlander. The months of late 1863 to early 1864, however, marked the combination of resources – in the form of the gift of a camera – and opportunity: her youngest child was twelve, her oldest recently married, and her husband away on the family estates in Ceylon. When she began making photographs, Cameron had none of the training in the visual arts then available to women in Victorian England, nor is she known to have enjoyed the hobbies of sketching or watercolour painting common to women of her class. In England during the 1860s, photography was applied to a diverse range of commercial, amateur, scientific and artistic intentions, with varied, occasionally overlapping, audiences and markets. Cameron's artistic context for her photographs was her vital social circle of painters, writers, critics and intellectuals. Her own ambitions for her art and her tremendous drive were crucial to her accomplishments. In 1874, ten years after she began her work in the medium, Cameron wrote a memoir of her photography entitled *Annals of My Glass House*. Apparently unfinished, and unpublished during her lifetime, *Annals* is a rich introduction to Cameron's photography, providing a vivid account of her activities and her distinctive point of view. In her 'glass house' – a windowed room previously employed as a chicken coop – she used an unwieldy view camera on a tripod (she specifically mentions moving it to Little Holland House to photograph Thomas Carlyle). The wet collodion process that was the standard for photographic negatives at that time required that the glass plate negative be sensitized in a liquid before it was

laced in the already focused camera. Once the exposure was made, the negative
ad to be developed immediately, while still 'wet' (this was done in Cameron's
arkroom, a former coal cellar). After processing and drying, the glass negative
/as placed in contact with a sheet of albumen printing paper, and exposed to the
unlight, then processed, washed and dried. In her correspondence, Cameron
laimed to have done all this work herself, with only the assistance of her
ousehold servants.

djacent to her home, Cameron's glass house was not only a practical
/orkspace, but also an arena of her own invention, where her domestic life and
nternational fame as a photographer joined and flourished. In the *Annals*, she
/rites of running to the dining room to show new images to her husband, which
.e would greet with enthusiastic praise, and who seems not to have minded
/hen wet negatives and prints dripped ruinous chemicals on the table linen. In
er words, when she converted the chicken coop into a photographic studio, 'the
ociety of hens and chickens was soon changed for that of poets, prophets,
ainters and lovely maidens'. This comic comparison of the glass house's old and
ew occupants attests to the power of art to transform life, and, more precisely,
o that of her photography to transform her own. Cameron begins the *Annals* by
oting the travels of her photographic exhibitions in Europe, America and
.ustralia. She emphasizes the extent to which she values the opinion of artists
who 'immediately crowned me with laurels') over the commercial photographers
/ho 'value fidelity and manipulation' and sales before art. She mocks the
retensions of a Miss Louisa Summerhouse Donkins ('a Carriage person'), who
romises in a letter that she will arrive with her dress unwrinkled if Cameron will
ake her likeness. 'Not being a professional photographer', Cameron declined the
equest, but had she accepted, she would have much preferred that Miss

Donkins' dress be creased. Her gentry-level disdain for middle-class and nouveau riche aspirations was expressed in her photographs through a lack of interest in matters of costume or setting extraneous to her artistic vision. In this spirit, Cameron makes short shrift of criticism, whether from the Photographic Society of London ('unsparing and too manifestly unjust for me to attend to it') or even Tennyson's comparison of her portrait of him to a commercial photographer's work. Instead, Cameron heralds her awards, her international acclaim, and quotes extensively both from a Berlin admirer's letter to the 'lady artist' and John Herschel's praise for her work.

A similarly subjective approach can be discerned from Cameron's description of the gift of her camera by her daughter and son-in-law, Julia and Charles Norman. She quotes her daughter's suggestion that 'it may amuse you Mother to try to photograph during your solitude at Freshwater'. The death of Julia Norman in childbirth the year before Cameron wrote the *Annals* imbues these remarks with the quality of a memorial. However, in Cameron's letters of 1864 to Sir John Herschel she relates the event differently, crediting the gift solely to Charles Norman. She also describes in these letters other early events not mentioned in the *Annals*, such as her experiments photographing a sitter by firelight, and the instruction in photography she received from the painter David Wilkie Wynfield. A member of the St John's Wood School of artists, Wynfield had recently published a portfolio of photographs, *The Studio*, comprising bust portrait photographs of contemporary artists taken in the style of old master paintings. Cameron's reasons for omitting Wynfield from her *Annals* are unknown, but by acknowledging him she would of course have mitigated her emphasis in the publication on her singular accomplishment as a photographer. Cameron also reports the observation of her youngest son, Henry Herschel Hay

Cameron (now himself, his mother proudly notes, a remarkable photographer), on her camera technique. Her first successes in shallow-focus photographs, he suggested, was due to the fact that 'when I found something that to my eye was very beautiful I stopped there, rather than screwing the lens to the definite focus all other photographers insist upon'. By repeating her son's observation, Cameron stresses her artistic originality and her deliberate emphasis on beauty above literal depiction, rejecting the criticisms of some photographers that her use of the lens was careless or incompetent.

Cameron's photographs are exclusively of people, whether portraits, a model portraying a character from history or literature, or several models in a tableau vivant. She is not known to have photographed, for example, still-life images, landscapes, or studies of buildings and monuments – subjects also considered to be photographic art at the time. By this means she aligned her photography with the higher levels of academic art, in which the figure was central to the representation of ideas, emotions and narratives. While her models may hold props, or pose swathed in great wraps of fabric that hide their contemporary clothes, the figure remains central to her images. And although she works within a historical tradition, Cameron is strikingly modern in her use of the photographic medium itself, employing imaginative, dramatic lighting and vivid organization of space and form through depth of field and lens focus. Some of Cameron's earliest works also involve experiments with printing, or with painting or marking the photographic negative. She was initially willing to keep the traces of uneven negative coating and development in her images, but these had largely disappeared from her work by 1865. She did not, however, subordinate aesthetic accomplishment to technical niceties – the 1866 photograph *Sappho* (page 59), for example, is printed from a broken negative. But a review of her

work between 1864 and 1865 illustrates a gradually growing control in her ability to use the lens and work with light. The most significant sign of her growing assurance in the exploration of photography as an artistic medium was her decision, evident in photographs from mid-1865 onwards, to switch from the 9 x 11 inch negative format she began with, to a larger one. Her new camera was even larger, and the work involved in processing an 11 x 15 inch negative was even more difficult. But the effort was directed to a goal: to do, as Cameron explained to one correspondent, what Watts had always urged: to make 'photographs that are not only from the Life, but to the Life, and startle the eye with wonder and delight'. Cameron had an artistic vision for her photography and she worked with scale, focus, lighting and posing to achieve it.

Initially, Cameron used the large format for portraits (pages 69 and 77) and for heads of characters, usually women, but also men and children, from history and literature. The life-size heads taken from 1866 onwards are among Cameron's most impressive works. She worked with this large scale almost exclusively thereafter, even when posing multiple figures in a tableau vivant or making half-length studies. Her changing approach to her format, however, did not make the process of posing for her camera easier. The large lens and negative entailed especially long exposures, in which any motion made by the model could ruin the desired result. Several of Cameron's models, particularly those who were children when their photographs were made, describe holding still for seemingly interminable sessions before her lens. Clearly, even allowing for some retrospective exaggeration, posing for Cameron was an arduous task, since her ambitions for her artistic photographs outweighed the convenience of either model or photographer. It is not surprising that Cameron's favourite female model, Mary Hillier, was also her household maid. Hillier's sessions before the

…amera may have been personally rewarding, but they were an exchange of one type of household service for another.

At the beginning of her career, after only a few weeks of work and a considerable struggle with the difficult photographic process, Cameron presented an album to Watts. She described the contents in her inscription as her 'first successes in her mortal, but yet divine! art of photography'. This characterization of photography reveals a great deal about her understanding of her art. She saw the dual significance of 'mortal but yet divine' in every trace of light cast onto her negative. The result of her understanding was an extraordinary expansion of the capacity of the human figure to embody her artistic idea. The seemingly simple image of Kate Keown is a case in point (page 51). Her young face and slightly expectant expression are strongly shaped by the darkness that throws her head into relief, while the shadow on her face to the left seems to play across a single plane of space. The highlights on the surface of her eyes are hard to differentiate from the personality that is illuminated through the eyes themselves. The curves of the drape at Keown's neck, and the tondo form that Cameron selected, centre her head, at the same time lending dynamism to the slight turn of her face and gaze. Contemporaneous with Dante Gabriel Rossetti's paintings of women's faces, several of Cameron's most impressive images of women (pages 89, 103, 105) use her model's facial expression, composition and subtle lighting to convey the psychological interior as well as external features of her sitters. Later photographs portray a single female figure against a foliage-covered wall (pages 113, 115, 121). In these images, the earlier dramatic contrasts of light and dark are absent, and a more diffuse lighting makes the overall image more harmonious, suggesting the symbolic connection between femininity and nature.

Cameron's work differed from Wynfield's in its concentration not only on portraits, but also on narrative subjects. It also departed from Watts' example in its extended interest in overtly Christian subjects, usually the Madonna, or Madonna and Child. (Mary Hillier modelled for the subject so often that she earned the nickname Mary Madonna.) These images of the Madonna and Child are also related to her early photographs of children, partially clothed to resemble *putti* or angels, or in loose drapes that allude to the costumes of an indeterminate past. At a historical moment when women artists did not have access to the nude model for life-study classes, the child was Cameron's only opportunity to photograph the human body. In one important instance, Cameron used her beloved grandchild as model for these figure studies (pages 35 and 37), an example of the way in which her photographic art crossed and conflated boundaries of domestic and public, artistic and personal. A number of the female characters and allegorical figures portrayed by Cameron were indebted to contemporary and historical sources ranging from late eighteenth-century paintings and nineteenth-century graphic pictures, to literature, Italian old master paintings and the characters who were the basis for fancy-dress costumes. Yet Cameron frequently altered the attributes of these stock characters, imbuing them with the seriousness and beauty that form the hallmark of her art.

Cameron's presentation of her first album of photographs to Watts was a way in which to secure his artistic advice. Between 1864 and 1865, she presented several, often beautifully appointed, albums to the members of her circle who were potential sources for advice, support and patronage. (She also made gifts of albums to her sisters, whose husbands and children she photographed.) An undercurrent in Cameron's photographic production is the extent to which

finances influenced the amount of work she could do in her glass house. The family finances were in increasingly poor shape during the ten years of working in England. Cameron reports in her letters the need to recoup her outlay of expenses with sales, and complaints about her spending by her wealthy son-in-law, Charles Norman, could well apply specifically to photographic expenses.

Her intention to publicize her works and generate sales was expressed in her decision to register them for copyright protection. There are more extant prints than titles copyrighted, so the decision to register an image was, perhaps, based upon her appraisal of its marketablity. The copyright registrations, which she made until the autumn of 1875, therefore give an insight into her expectations for sales. The photographs taken in the first two years of her career (1864–5) comprise slightly less than half of the total number of images registered. The total for 1867 was also high. However, it seems that she subsequently registered images only when she considered them especially marketable. Her regard for her work, and expectation of sales to an audience that would appreciate it, is also indicated by her decision to have carbon-print reproductions of a selection of her images made by the Autotype Company in London. Carbon prints were more stable than albumen photographic prints, and she experimented with the different coloured pigments used in the process to give the deep, purplish tones of albumen paper as well as the reds and oranges of chalk drawings. The London print sellers Colnaghi and Company began offering her photographs for sale in July 1865, but not, as she explained in her *Annals*, as the work of a professional photographer; Cameron marketed her photographs as works of art.

Cameron organized three one-person exhibitions of her work in London galleries in November 1865, January 1868 and November 1873. The 1873 exhibition, while

including new titles, had the feel of a retrospective. As early as the late 1860s Cameron wrote to one of her patrons, Lord Overstone, explaining that she had taken photography to great heights and implying that she had achieved her ambition. Reviews of Cameron's early contributions to photographic societies and annual exhibitions were divided between the British photographic press and the journals and newspapers published for a more general audience. Initially, critics acknowledged Cameron's debt to Wynfield, then described her technique as, among other qualities, 'slovenly'. Her own social contacts wrote sympathetic, even laudatory, reviews in such journals as *The Athenaeum* and *Macmillan's Magazine*. These reviews, in turn, aroused the wrath of commercial photographers, who placed great stock in technique. Initially, they perceived in Cameron's unorthodox approach and favourable reviews a potential challenge to their own markets, specifically for portraits. Yet, from some quarters of the photographic community, Cameron consistently won praise for her artistry, earning medals and honourable mentions in international exhibitions and other photographic shows. The technical virtuosity of her life-size heads earned grudging acknowledgement even from members of the commercial photographic press. By the 1870s, the perceived threat that her unusual use of focus would become a desirable popular style had not materialized, and the often caustic criticism in the photographic press was informed more explicitly by class differences. Cameron's last major project in England, her *Illustrations to Tennyson's Idylls of the King* (1874–5), epitomizes many of her concerns for her photography: the imaginative challenge of making images of Tennyson's work; public affiliation with Tennyson (whose suggestion that she make the photographs became part of her publicity campaign for the project); the hope that she could make sales of this beautiful gift book during the holiday season; the importance to Cameron of her large photographs as works of art whose qualities were

iminished when reproduced small scale. While her selection of incident coincides in several instances with Gustave Doré's popular engravings after the *dylls*, her photographs differ greatly in their reliance upon gesture, facial xpression and a shallow pictorial space to intensify the viewer's imaginative nvolvement with the action.

n the autumn of 1875, Cameron and her family left for Ceylon in order to be loser to their estates and to two of their sons, who lived and worked there. She eturned to England only once before her death in Ceylon after a short illness in anuary 1879. Comparatively few images from the last four years of her life exist pages 123 and 125) and her inscriptions on the images are infrequent. In these hotographs, Cameron maintained her regard for the human figure, but it was now informed by the position of the British colonialist, who considered the Ceylonese models culturally subordinate, particularly evident in the sexual double standard of photographing the naked chests of the males. These photographs raise provocative questions about the place of her artistic photography within larger social systems of value and power.

When looking at photographs, it is often difficult to go beyond the familiar expectation that they are truthful records of what was in front of the camera. According to such expectations, Cameron's artistic photographs, though richly expressive, would be mere records. However, her ambitions for her photography were much greater than this. Her grasp of the 'mortal, but yet divine! art of photography' sustained her extraordinary innovations in the use of light and the capacities of the lens to render form in space. Her photographs aspire to the artistic canon of traditional painting and sculpture, joining these precedents to the fugitive shadows and multiple images of a new, modern medium.

Annie, 1864. Cameron characteristically inscribed this strikingly direc
photograph with the proud statement, 'My first success'. The model is th
ten-year-old niece of a friend of Alfred Tennyson. The massing of forms in th
background, cloak and unruly hair foreshadow Cameron's future work as
photographer with an exceptional ability to invent bold portrait compositions.

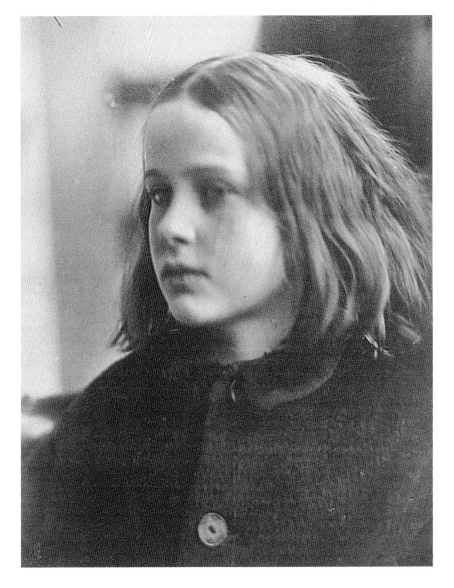

Mary Ryan with Photogram Frame of Plant Forms, c.1864. Cameron's approach to photographic techniques was experimental and imaginative. This sitter is Mary Ryan, an Irish girl whose beauty inspired Cameron to bring her into her household. Ryan's portrait is framed by a photogram of plant forms, made by placing the plants between the photographic glass negative and the light-sensitive albumen paper. In sharp focus when pressed beneath the glass negative, the traces of the plants beyond the edges of the glass become less distinct, suggestive shapes. The photograph's fascination lies in the parallel between the photogram shapes of plants and the lens-based image of tree branches and leaves above Ryan's head.

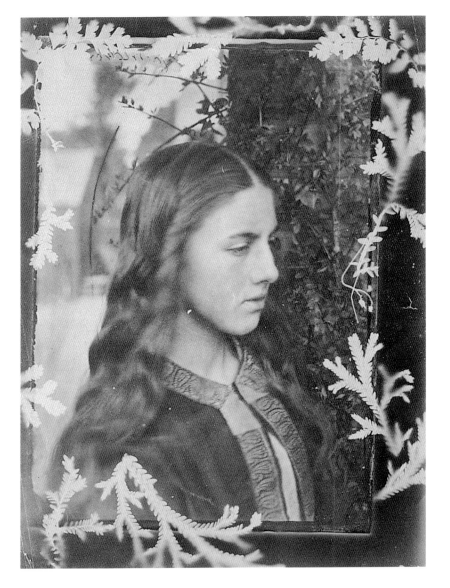

Mary Hillier as Madonna with Two Children, 1864. Cameron posed her favourit
model, housemaid Mary Hillier, and two children according to the iconography c
Christian art. By scratching away the negative emulsion (visible to the left o
Hillier's face), she creates a halo of 'light'. Hillier's serene Madonna contrast
with the blurred forms of the children, who had difficulty holding still for th
long exposure. Cameron painted her signature and the inscription 'From Life' o
the negative.

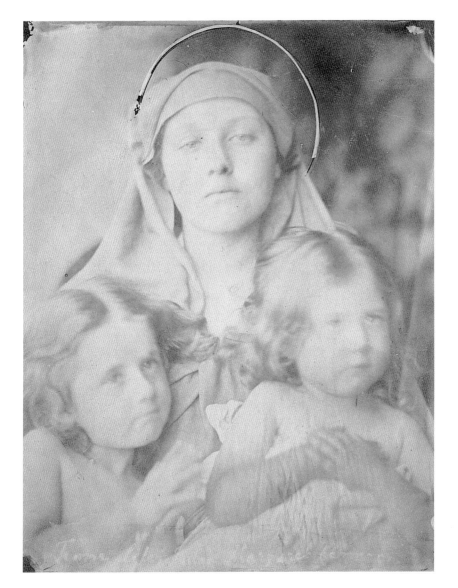

Goodness, One of a Series of Nine Illustrating 'The Fruits of the Spirit', 1864
Cameron's title refers to a Biblical passage in the sermons of Paul to the Galatians (5:22–3), 'But the fruit of the Spirit is love, joy, peace, long-suffering, gentleness, goodness, faith, meekness, temperance, against such there is no law.' In all Cameron's images in this series is the figure of a woman, frequently with one or two children. Hillier's gaze at the camera is strong, but not confrontational. In this photograph, as in many others, Cameron presents an ideal of femininity that combines goodness with qualities of sensuality and vulnerability.

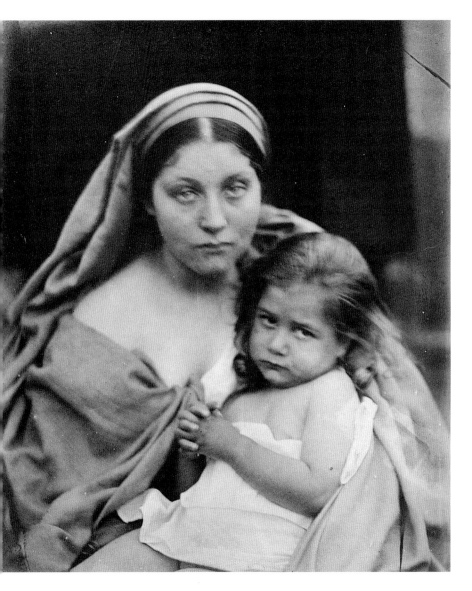

Charles Hay Cameron, 1864. A story of Julia Cameron's life at Freshwater relates how she invited guests upstairs to where her husband Charles was sleeping, flung open his bedroom door, and pronounced, 'Behold, the most beautiful old man in the world!' Charles Cameron was nearly 70 years old when she made this portrait. Cameron softens the focus on texture and depth of field to describe Charles' withered face and hair. His bright eyes and alert gaze convey the intelligence of this man of politics and letters.

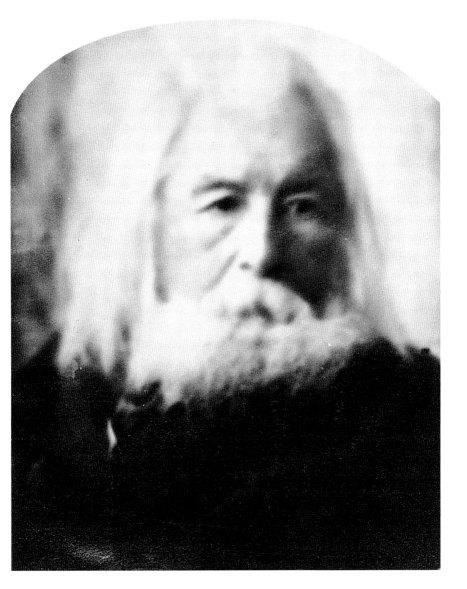

William Holman Hunt, 1864. One of the founding members of the Pre-Raphaelite Brotherhood, the painter Holman Hunt (1827–1910) was a close friend of George Watts, Cameron's artistic adviser. Hunt had travelled to the Middle East in 1854–5 in search of historically accurate sources for his religious paintings. His 'Eastern dress', the very low camera angle and the way in which he gazes into the distance, create a vision of the artist as romantic traveller.

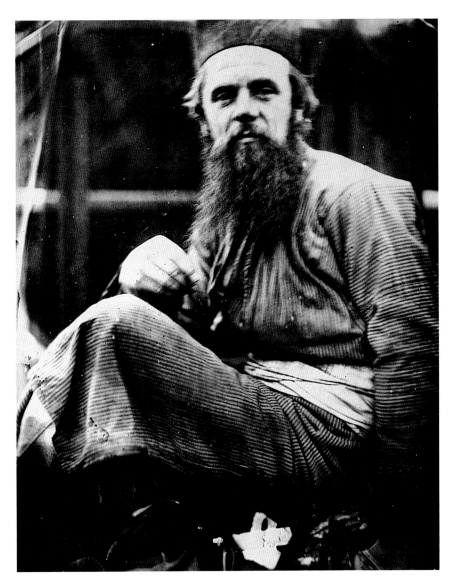

The Turtle Doves, 1864. Titled in ink on the reverse, this print is cropped to an ova
that encloses the figures of the small, kissing children, and may well be a study for
other more finished, mounted versions. While embracing children had appeared
before in literature and the visual arts, this open-mouthed kiss is unusual and
astonishingly sensual, despite the awkwardness of the children's pose.

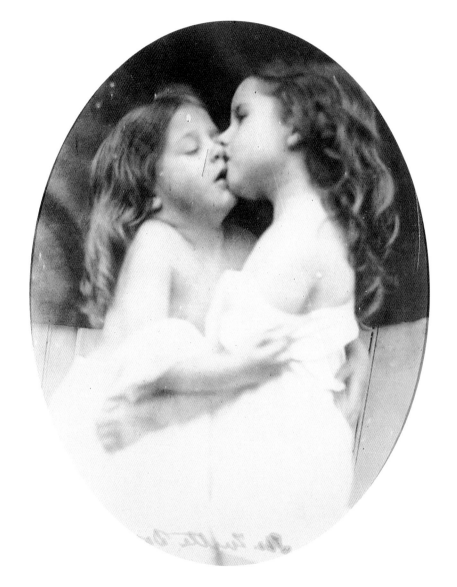

The Infant Bridal, 1864. In *The Infant Bridal* (1855), a poem by Aubrey de Vere two children are betrothed to each other to bring peace to their feuding kingdoms. Cameron posed her two young models in imitation of adult gestures – the girl leans on the boy's shoulder, his arm protectively around her – but costumed them like *putti* from an Italian Renaissance painting.

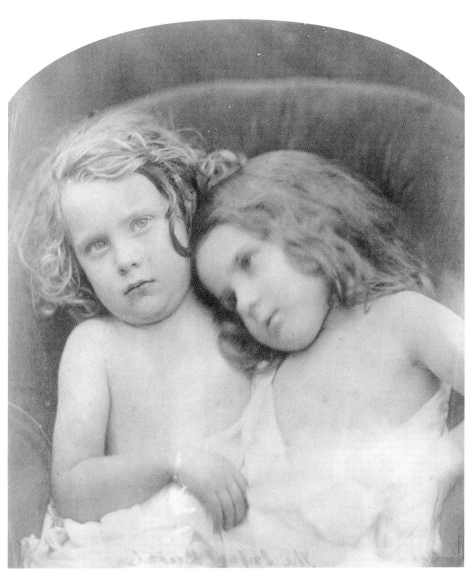

Paul and Virginia, 1864. Paul and Virginia are the protagonists of Jacques Henri Bernardin de Saint Pierre's romance of 1787. Their ill-fated love begins in childhood, spent on a remote island, suggested here by the Indian umbrella they hold between them. After a separation, Virginia returns to Paul, but her ship suffers a wreck. Before Paul's eyes, Virginia chooses to drown rather than removing the clothes that are pulling her into the sea. Paul then dies of grief.

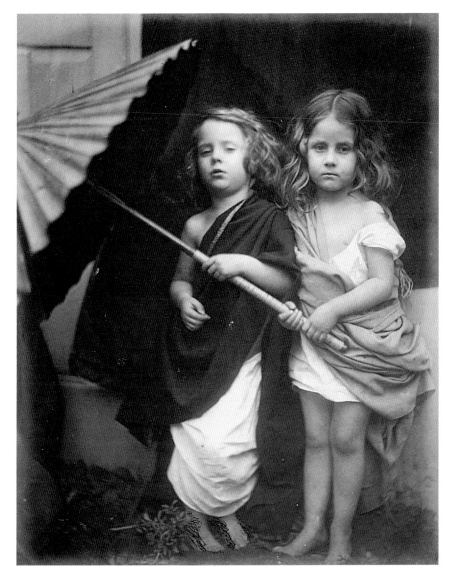

Devotion – Archie, My Grandchild, 1865. Cameron inscribed one copy of this print 'my chef d'oeuvre'. Two-year-old Archie Cameron was the first child of Cameron's eldest son, Eugene Hay Cameron, and his wife, Caroline Catherine Brown. Eugene worked for the British colonial administration in Barbados and this photograph was made during Archie's first visit to England in 1865. While Cameron used the iconography of the watchful Mary and the baby Jesus, the devotion between photographer and the child is the more intense relationship: Cameron reserves for herself the full view of the baby's face, hair and chubby hand.

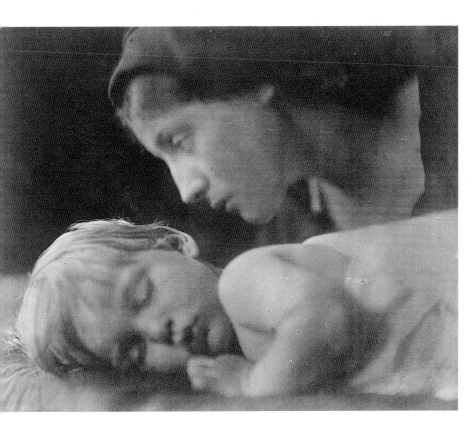

Shadow of the Cross — Archie, My Grandchild, 1865. In this photograph Cameron elaborated on the iconography of Mary and the child Jesus as a prefiguration of the sacrificial death of the adult Christ. She took this full-length view of Archie to give a large scale to the figure of the child. His crossed legs and shirtless body, the wooden cross in his hands and the flowers at his legs, allude to the crucifixion of the adult Jesus. Mary Hillier's dark-clothed Madonna is part of both this sacred scene and of the domestic interior behind it.

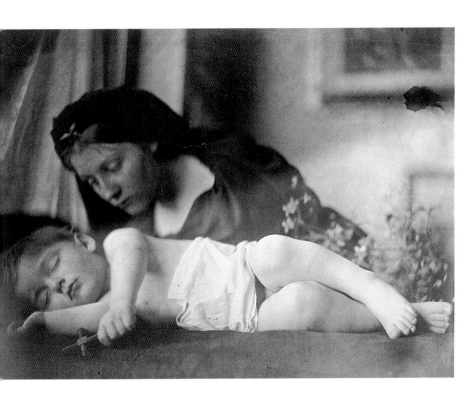

Henry Taylor, 1865. Cameron inscribed copies of this portrait of poet and essayist Henry Taylor (1800–86) 'A Rembrandt' in reference to the Dutch painter's use of intense light emerging out of darkness. She met Taylor and his wife shortly after the family's move to England in 1846. Taylor was among the prominent men whom Cameron and her sisters cultivated as friends. In 1850, he was under consideration for the position of Poet Laureate, eventually awarded to Tennyson. Cameron draped her male models in imitation of portraits in historical paintings and sculptures and to hide their mid-Victorian dress.

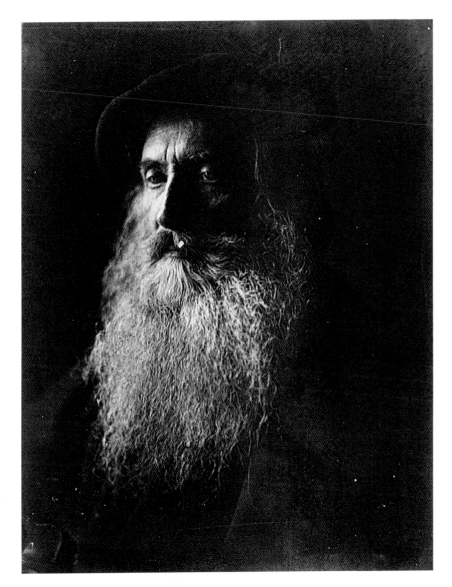

Alfred Tennyson, 1865. Poet Laureate Alfred Tennyson (1809–92) was Cameron's friend and neighbour on the Isle of Wight. Tennyson himself nicknamed this photograph 'the dirty monk'. He declared it his favourite photograph of himself, except for a portrait by commercial photographer John Jabez Edwin Mayall. In Cameron's words, this was like comparing an 'Ideal heroic Bust' by contemporary English sculptor Thomas Woolner to one of 'Madame Tussaud's Waxwork Heads'.

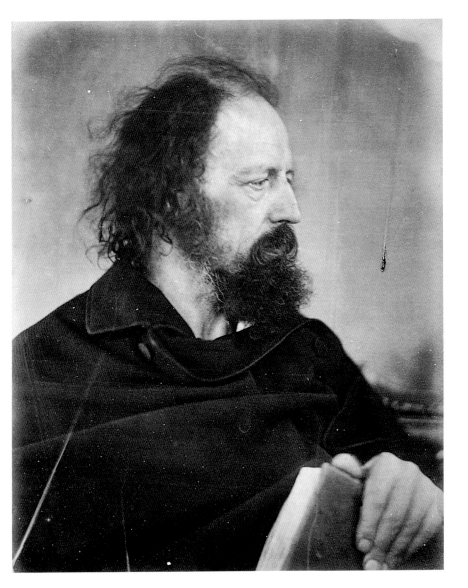

William Michael Rossetti, 1865. Art critic William Michael Rossetti (1829–1919) was the brother of painter and poet Dante Gabriel Rossetti and poet Christina Rossetti. It is likely that Cameron met him through his brother, who was a regular visitor to Sara Prinsep's salon. Cameron sought the critic's public support for her work, which he bestowed in the form of favourable remarks, published in 1867 in *The Chronicle*, on her 'surprising and magnificent pictorial photographs'.

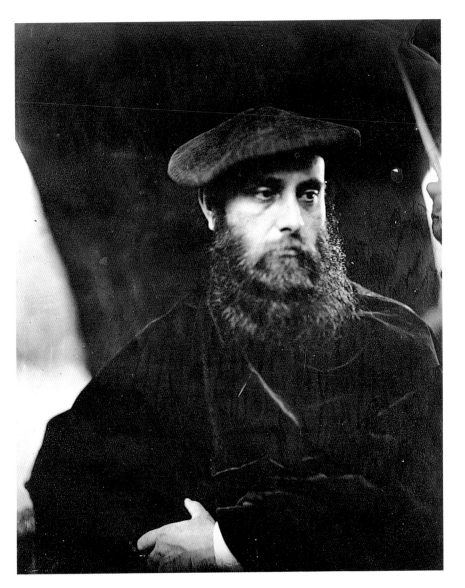

Whisper of the Muse, 1865. Painter and sculptor George Frederick Watts (1817–1904) was the prized artist in residence at Little Holland House and a close friend and artistic adviser to Cameron. Here, she poses him in an allegorical portrait as a figure of the Arts. One child represents a muse, about to whisper in the artist's ear as he prepares to play his violin.

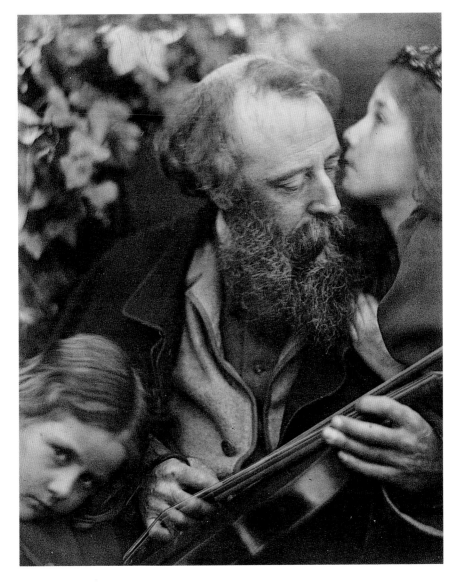

Henry Herschel Hay Cameron, 1865. Cameron chose a fitting horizontal format for this intimate portrait bust of her youngest son (1852–1911). Her lighting gives the thirteen-year-old sitter's profile a remote quality and plays on the cowlicks, tangles and uncombed strands of his hair. The photograph seems to reflect an attempt to retain the beloved face of a child in a boy who is growing up. Nearly a decade later, Cameron proudly noted Henry's own work in photography and his observations on her use of focus in her *Annals of My Glass House*.

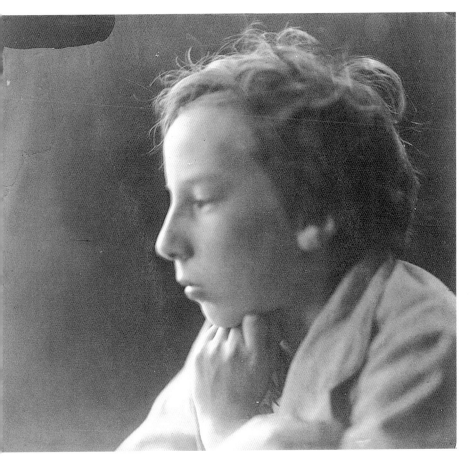

Queen Esther before King Ahasuerus, 1865. In the Biblical story from the Apocrypha on which this scene is based, Queen Esther pleads with King Ahasuerus to spare the Jews he has condemned to death. The King's fierce look upon Esther causes her to faint into the arms of her attendant. After she faints God causes a change of heart in Ahasuerus, who spares Esther and her people. Cameron's photograph depicts both the moment of Ahasuerus' power – when Esther faints – and the moment when he experiences a change of heart – his sceptre steadied by a finger, rather than held in his hand.

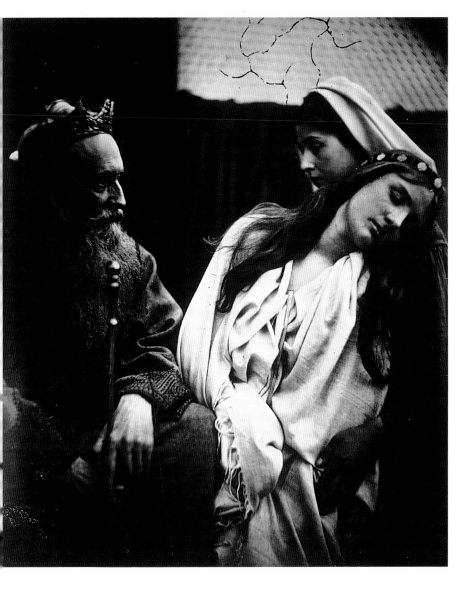

Kate Keown – Tondo, c.1866. In early 1866, Cameron began to concentrate on the human face as a meaningful visual form, exploring different effects of lighting and depth of field to represent the contours of the face and head, and carefully illuminating the eyes to convey emotions and states of mind. Here Cameron used the tondo format for her print, playing the lighting and focus on the model's features off the round completeness of the frame.

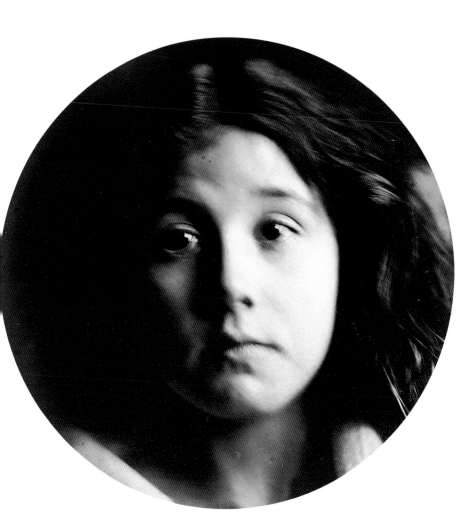

Philip Stanhope Worsley, c.1866. When Cameron made this photograph of Worsley (1835–66), a poet and translator, he was dying of tuberculosis. Cameron wrote of nursing him during the last months of his life, 'The heart of man can not conceive a sight more pitiful than the outward evidence of the breaking up of his whole being.' Worsley's head, leaning against what appear to be bedclothes, is raised up to the camera. His expression is determined and fierce – a rejection of pity.

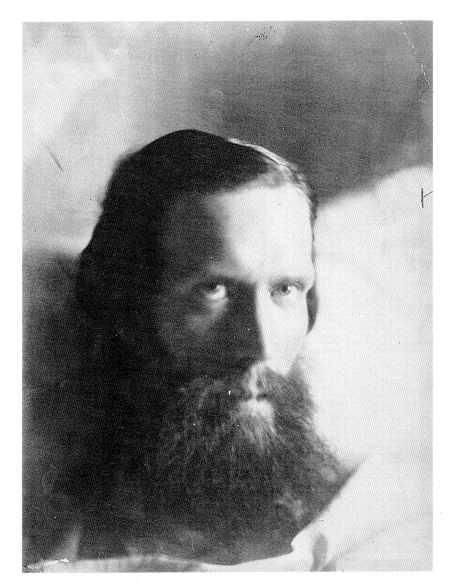

Mountain Nymph Sweet Liberty, 1866. Cameron frequently used poems as inspiration for her photographs. The figure in this photograph is derived from an evocative passage in John Milton's *L'Allegro* (1632): 'Come, and trip as ye go / On the light fantastik toe; / And in thy right hand lead with thee / The Mountain Nymph, Sweet Liberty.' Cameron proudly quoted Sir John Herschel's high praise of this photograph – 'She is absolutely alive and thrusting out her head from the paper into the air' – in her *Annals of My Glass House*.

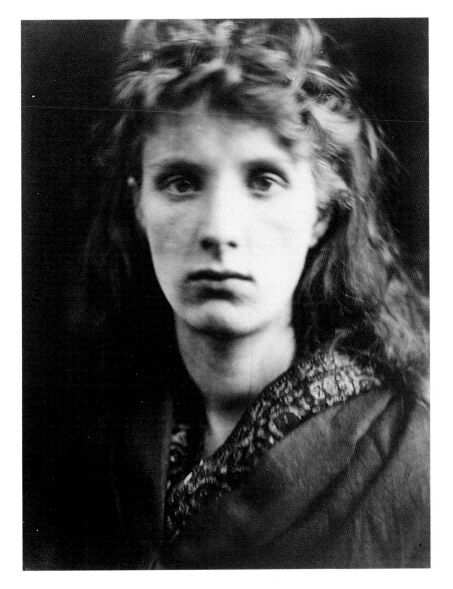

Beatrice, 1866. The sixteenth-century story of Beatrice Cenci, executed for hiring assassins to kill her brutal father, whom she accused of incest, was told in several nineteenth-century works of art, many inspired by Percy Shelley's 1819 drama *The Cenci*. Cameron's lighting and composition emphasize Beatrice's gentle beauty. Her resigned expression and downward look are belied, however, by the deliberate turn of her head to face the viewer, as if she hopes for mercy but cannot or will not request it.

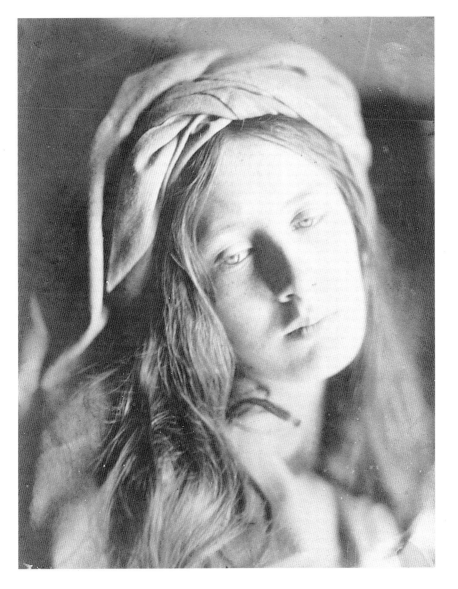

Sappho, c.1866. For this photograph depicting Sappho, the poetess of romantic love between women, Mary Hillier's intelligent and serene features are pictured in a bold profile, reminiscent of Italian Renaissance portraits. Cameron's regard for the success of the image is indicated by her willingness to continue to make the print despite the cracked glass negative.

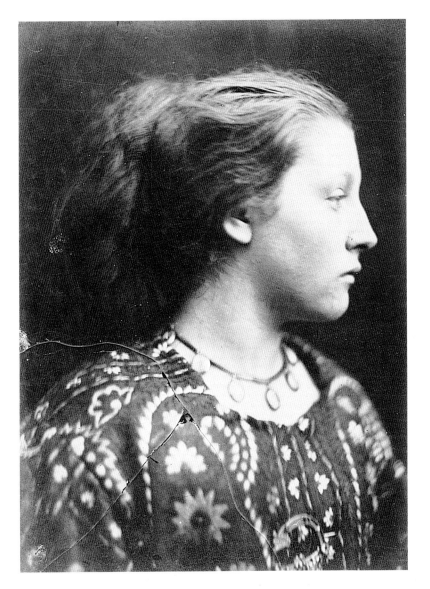

Light Study, 1866. Cameron inscribed this print, 'For Signor from JMC taken after sunset 7pm May 17.' The inscription, referring to her artistic adviser George Watts, indicates Cameron's interest in the soft, dim light remaining after the sun has slipped below the horizon. Her attention to the qualities of early evening light gives a chiaroscuro effect that enhances the model's skin, eyes, hair and the great curving folds of fabric that frame her face.

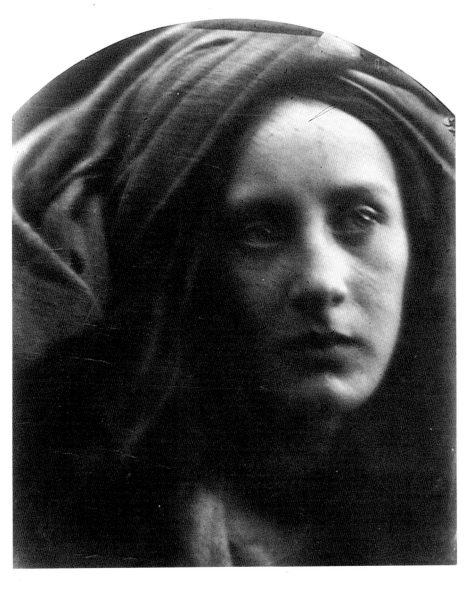

Ophelia, 1867. This image of the tragic heroine in Shakespeare's *Hamlet* is one of a group of photographs that Cameron inscribed to the poet and painter Dante Gabriel Rossetti. Some of Cameron's images are reminiscent of the sensual images of women that he had begun to paint by the early 1860s Cameron's image of Ophelia, however, sharply joins beauty to madness Ophelia's open mouth jars with the impersonality of the profile pose, while the delicately focused and illuminated rose at her neck contrasts with the disarray of her hair and her uncontrolled expression.

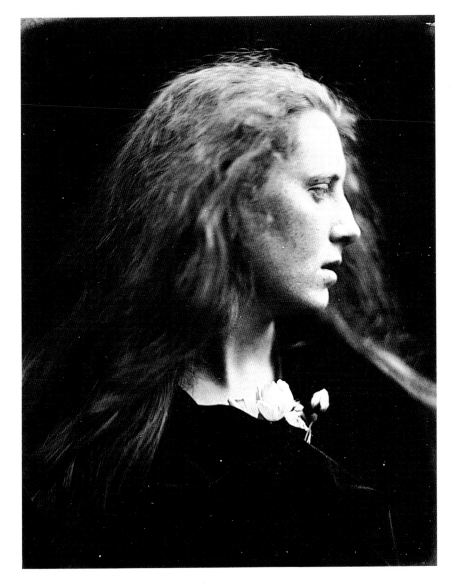

Teachings from the Elgin Marbles, 1867. Mary Hillier and Cylene Wilson, one of several orphaned children adopted by Cameron, pose as the Fates depicted in one of the marble sculptures from the ancient Parthenon that Lord Elgin sold to the British government in 1816. George Watts urged artists to study the Elgin Marbles to improve their figure drawing. Cameron applied Watts' advice to her photography by making two versions of *Teachings*, posing the models' heads differently in each.

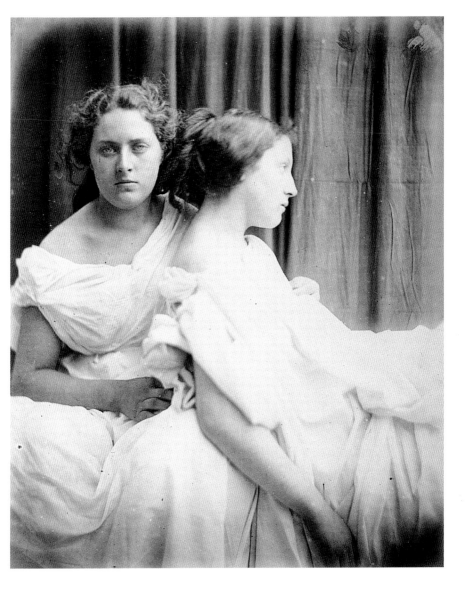

Romeo and Juliet, 1867. The models are Mary Ryan and Henry James Steadman Cotton, married in August 1867. In *Annals*, Cameron proudly related her part in their marriage, which transcended class differences. Their barely suppressed erotic longing positions the viewer as voyeur. Cotton's arms rest across Ryan's shoulders, his fingers laced in her hair, his profile almost touching her face. Ryan's eyes are closed. The indistinct shape of her arm buried in his cloak as she reaches to clasp his chest underneath the layers of his clothing seems to hold Cotton at a slight distance.

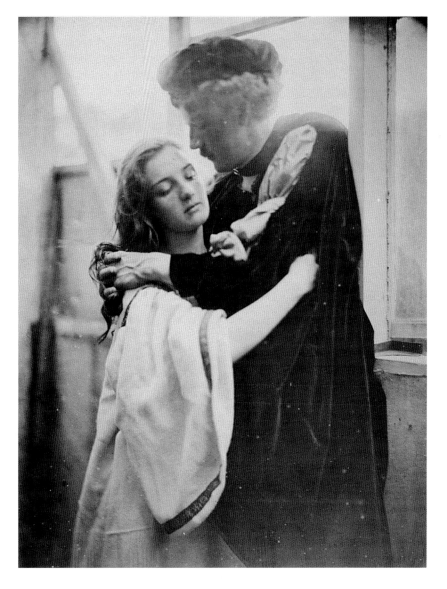

Julia Jackson, April 1867. This profile portrait is one of Cameron's most powerful and best-known photographs. Julia Jackson (1846–95) was Cameron's niece, godchild, namesake, frequent model and a famous beauty. Cameron took this and the following two photographs in the month before Jackson's marriage to Herbert Duckworth. The dramatic contrasts of light and dark in Jackson's profile and neck idealize her beauty, strength of character and intelligence.

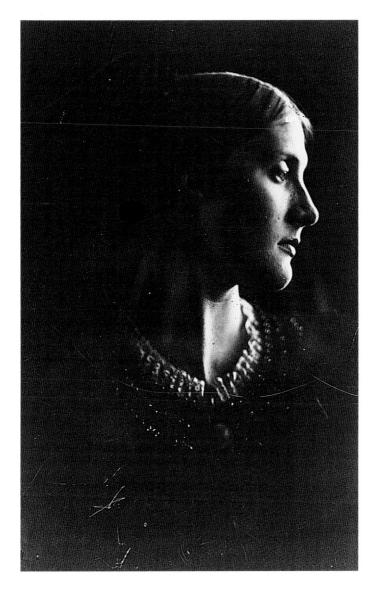

La Santa Julia, April 1867. Cameron inscribed copies of this print 'My Favourite Picture of All My Works', though this is a less iconic image than her profile portrait of Jackson. With her loosened hair and downward glance, Jackson is depicted in a more intimate way. Cameron uses dramatic lighting to lend power and a holy quality, reinforced by the title, to Jackson's calm, self-possessed expression.

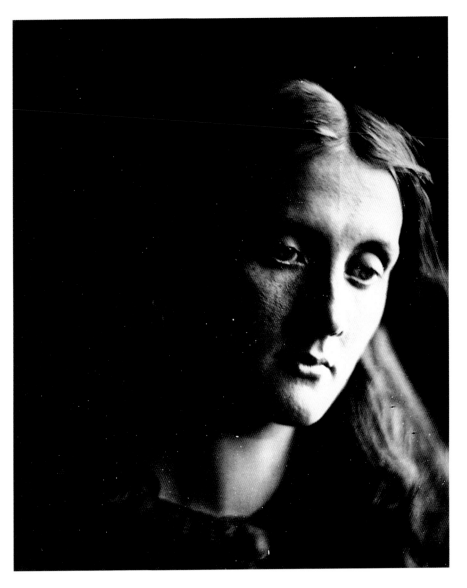

Julia Jackson, April 1867. Frontal and symmetrical in pose, though not in lighting, the effects of lens depth of field are almost schematically rendered in this image. The sharpest area of focus is on the plane of Jackson's eyes, forehead and hair, with the areas behind and in front of it softened in form. Cameron made at least three variants of this image from the same negative, flipping it to reverse the composition and achieve different effects.

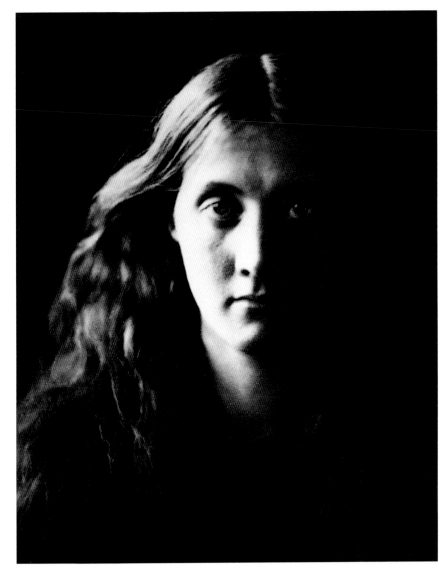

Thomas Carlyle, 1867. Cameron probably met the Scottish historian, biographer and essayist Thomas Carlyle (1795–1881) through his friend Henry Taylor. Her portrait powerfully unites a nearly frontal pose with three-quarter lighting establishing a confrontation with the viewer in which Carlyle's intellectual strength prevails. Cameron inscribed a copy of this print, 'Carlyle like a rough block of Michael Angelo's sculpture', aptly characterizing how her dramatic use of lighting and contrast strongly shapes the forms of his slightly blurred face, beard and hair.

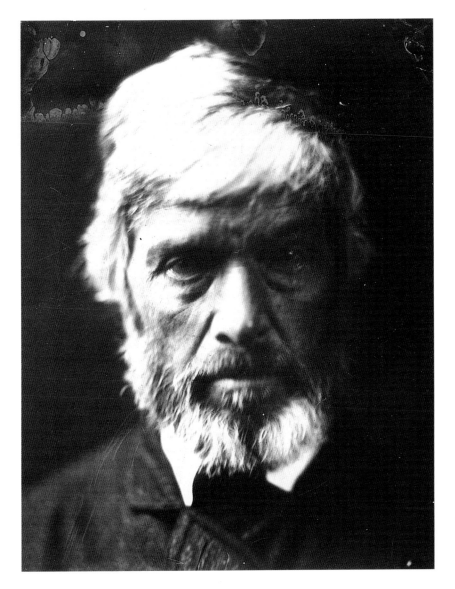

Thomas Carlyle Profile, 1867. The impersonality of the profile view vividly emphasizes Carlyle's intellectual qualities. Through Cameron's use of lighting his head is at once illuminated by light and is itself a source of light. The slight blurring of the head indicates the long exposure time, yet does not weaken the power of the profile.

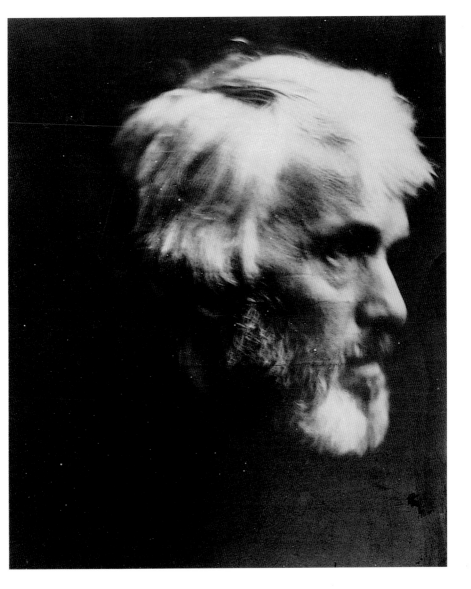

Edward Eyre, 1867. When Cameron photographed Edward John Eyre (1815-1901), he was at the centre of political and cultural controversy over his brutal suppression of a protest by Jamaican subjects against the British colonial government. In Cameron's portrait, Eyre is evenly lit, his expression non-committal. He looks down, but is not deferential. Cameron's portrait is a sympathetic one, as if she were presenting Eyre objectively for the viewer's judgement.

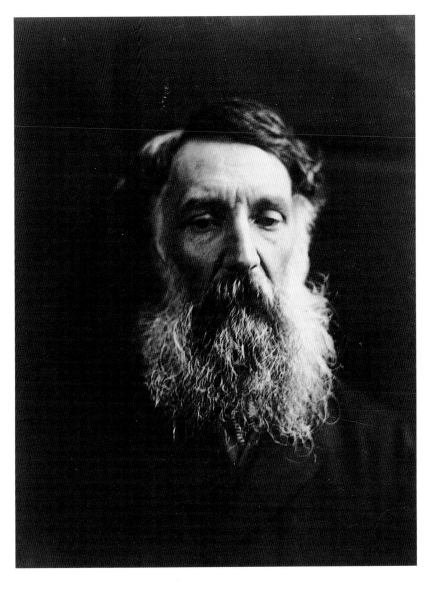

Sir John Herschel, 1867. When Cameron met the astronomer Herschel (1792–1871) in 1835, he was the leading scientist of his day, whose accomplishments later included decisive contributions to the development of photography. When Cameron wrote to Herschel in February 1864 to tell him of her own photography, she recalled how she had learned from him of the early developments in the daguerrotype and Talbotype. Her lighting of Herschel's eyes and the glowing forms of his tousled hair conveys the force of his intellect, despite the aged appearance of his whisker-stubbled face.

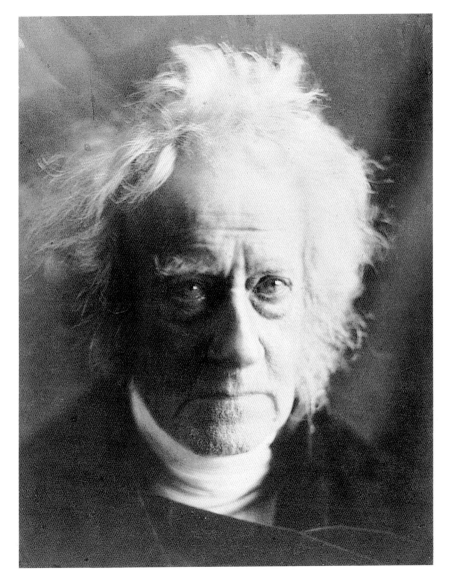

Henry Taylor, 1867. Cameron's lighting of this portrait of Taylor is even, in contrast to her earlier image of the poet (page 39). While the pose – head in hand, elbow propped on a surface – was a convention of commercial portrait photography, in Cameron's picture it is difficult to see what Taylor is leaning on. One could almost believe it was the camera base, so directly does he face the lens.

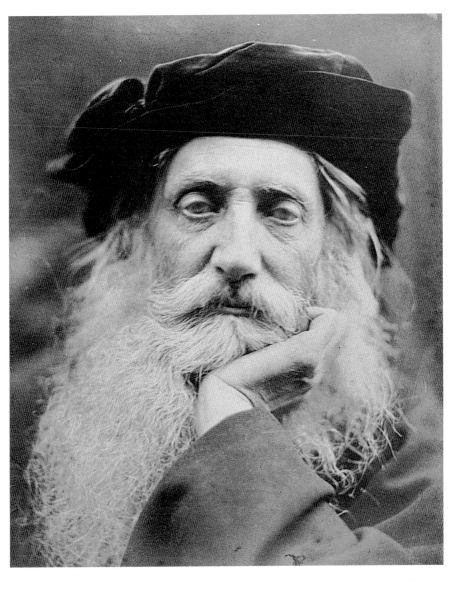

Alfred Tennyson, 1867. The dark fabric opens around Tennyson's neck in shapes that are oddly regular, as if the tones had been added to the negative after the image was made, to cover his light-toned shirt or skin. While Cameron's focus is very soft, the eyes dark and difficult to decipher, the lighting traces differences in surface between hair, skin and beard.

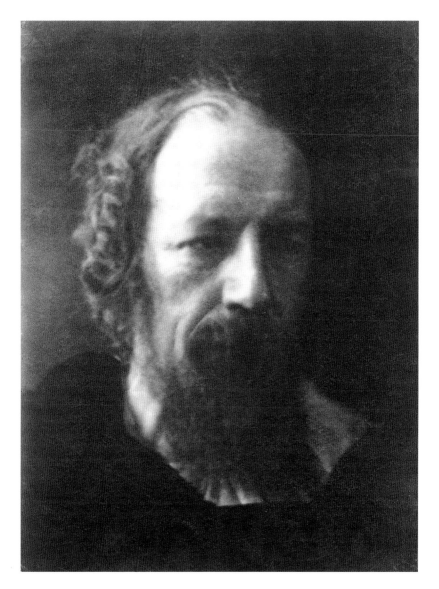

The Minstrel Group, 1867. Cameron inscribed 'We sing a slow contented song and knock at Paradise' on one copy of this print. She made several variants of the composition, changing the background, framing and poses of the models. The figure in the centre wears the costume of the *pifferari*, Italian itinerant musicians who were common subjects of genre paintings and fancy dress costumes.

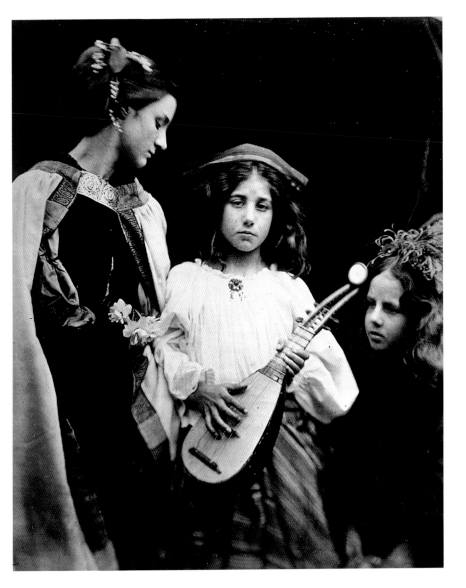

Call and I follow, 1867. This title is taken from a passage from 'The Song of Love and Death' in Tennyson's *Idylls of the King*, sung by the innocent Elaine as she falls into madness as a result of her unrequited love for Sir Lancelot. Hillier's strong head, expression and neck are only just contained by the upper frame of the photograph, an image of her increasing estrangement from reality, yet Cameron's dramatic viewpoint also gives a heroic aspect to Elaine's suffering.

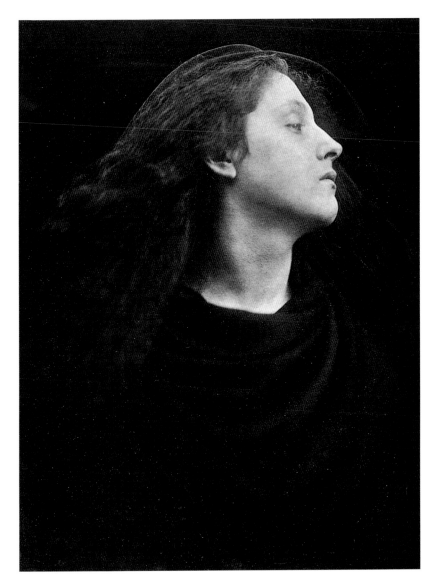

Mary Mother, 1867. A comparison between this photograph and an early image of Mary Hillier posed as the Madonna (page 21) indicates Cameron's growing assuredness. She has dispensed with the traditional iconography of halo and child to centre upon Hillier's face, enclosed and framed by sinuous arcs, folds and gathers of veil and dress. Hillier's downward look, away from the light, and the vulnerable wisps of hair at her forehead, signify Mary's humility amidst the dramatic, otherworldly lighting of her garments.

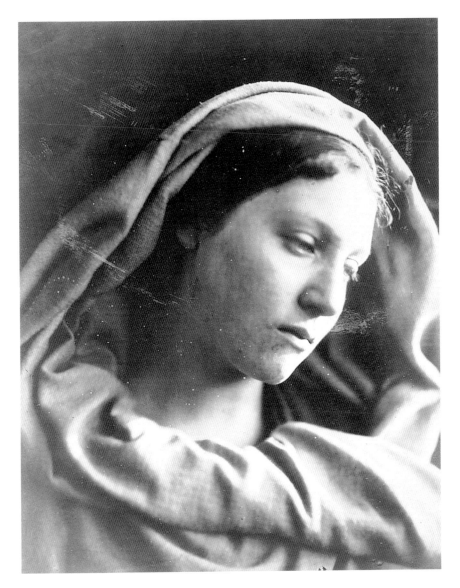

Julia Norman, 1868. Julia Hay Cameron Norman (1839–73) was Cameron's oldest child and only daughter. In *Annals*, Cameron attributed the gift of her first camera to her daughter and her husband, Charles, a wealthy banker. Married in January 1859, Julia and Charles Norman had six children before her death in childbirth in October 1873. Unlike Cameron's other namesake, Julia Jackson, her dearly loved daughter appears in relatively few photographs.

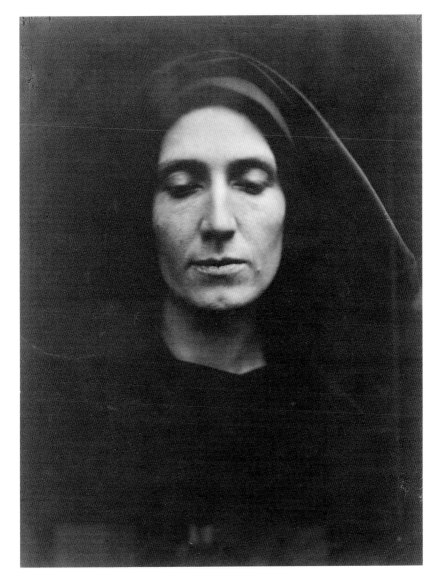

Rosebud Garden of Girls, 1868. The title of this photograph is derived from the line, 'Queen rose of the rosebud garden of girls' in Alfred Tennyson's poem 'Maud' (1855). The models are the four Fraser-Tytler sisters (left to right) Eleanor, Christina, Mary and Ethel. The sisters are dressed similarly and all posed with hair unbound, but each holds a different kind of flower. Mary Fraser-Tytler, who studied art in Dresden and at the Slade School in London, married George Watts in 1886.

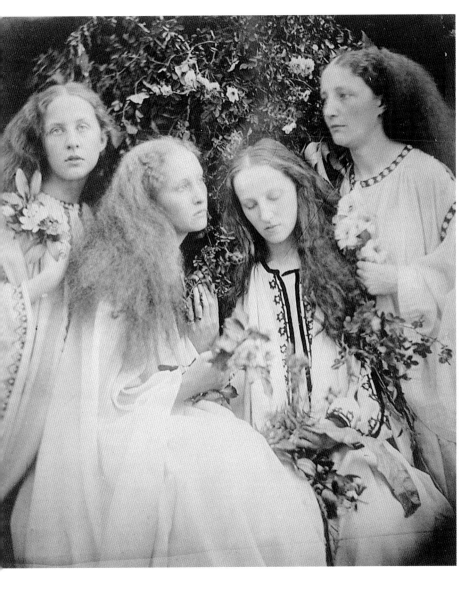

Charles Darwin, 1868. Charles Darwin (1809–82) and his family summered in Freshwater, where Cameron took this and other portraits of the English naturalist. The publication of Darwin's theories on human evolution in *On the Origin of Species* in 1859 was a major, controversial event in Victorian culture. It is fascinating to ponder whether or not the simian-like aspect of Darwin's profile was Cameron's comment on his ideas.

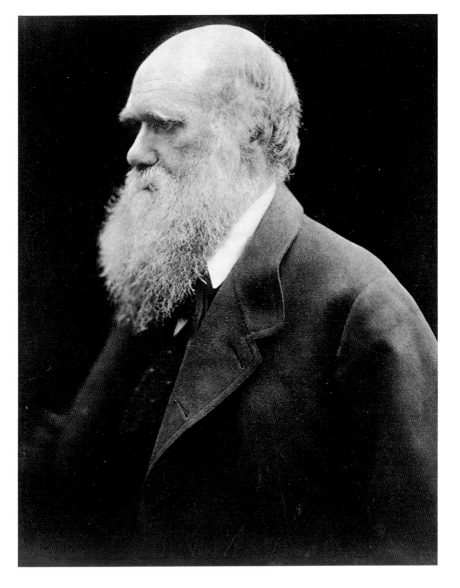

Dejatch Alamayou, 1868. The Abyssinian Campaign of 1867–8 was a well-publicized undertaking in which a British military force rescued Europeans imprisoned by the Emperor of Abyssinia, Tewodros II. He committed suicide, leaving his son and heir, Prince Alamayou, an orphan. Cameron photographed the Prince and his entourage when they visited the Isle of Wight. The picture is taken from below to imply his royal stature, while his pensive, sad expression alludes to the tragic loss of his father. The shield and spear contrast with the incongruous doll on his lap. Cameron quickly copyrighted this and other images of the Prince in anticipation of sales generated by the publicity surrounding the Campaign.

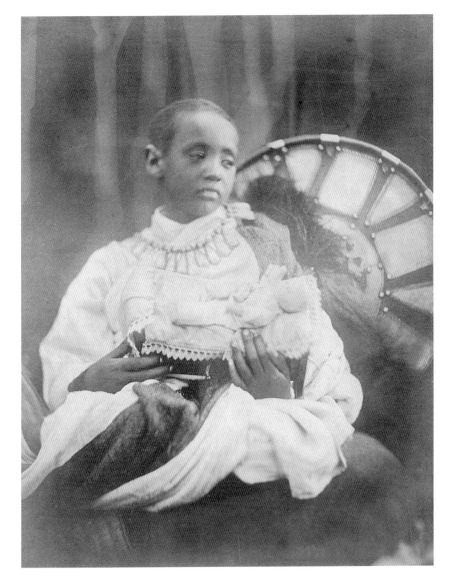

The Kiss of Peace, 1869. Cameron emphasized the delicacy of model Mary Hillier's sensual kiss upon the brow of a younger woman by its contrast with the energy of her pose, conveyed by the arc of her neck, the prominent curves of her garment and the strands of her unbound hair.

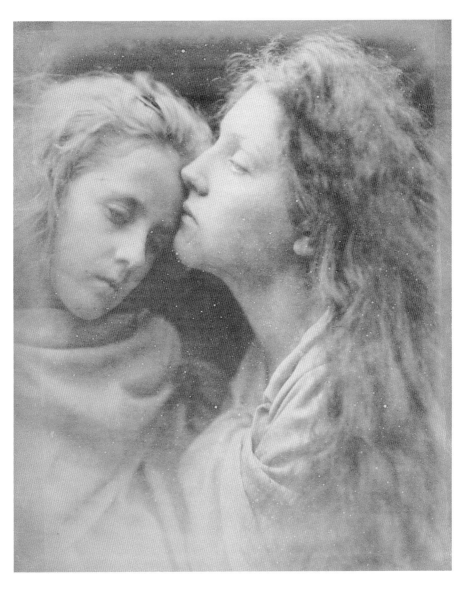

The Dream, 'Methought I saw my late espoused saint', 1869. Cameron's inscription quotes John Milton's 'On his Deceased Wife' (1658), which reads: 'as yet once more I trust to have / Full sight of her in Heaven without restraint, / Came vested all in white, pure as her mind: / Her face was veil'd, yet to my fancied sight / Love, sweetness, goodness in her person shined / So clear, as in no face with more delight. / But oh! as to embrace me she inclined, / I waked, she fled, and the day brought back my night.'

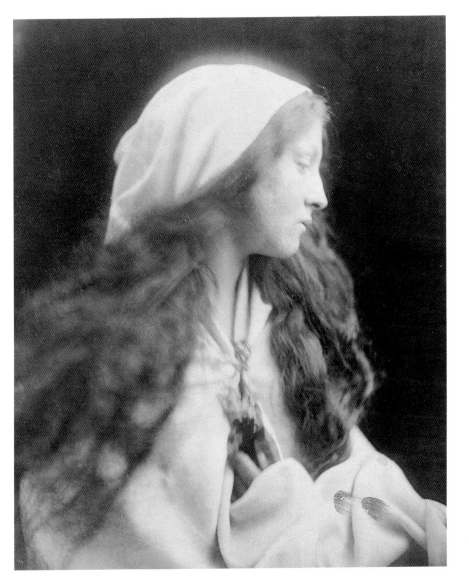

The Angel at the Tomb, 1869. After Christ's resurrection from the dead, God sent an angel to guard His empty tomb. The angel's face glowed with a heavenly light, which Cameron represents in her photograph with an intense burst of illumination, different in quality from that in the rest of the photograph, upon model Hillier's forehead. Cameron indicated the meaning of the light in her inscription, 'God's glory smote her on the face, a coruscation [sic] of spiritual, unearthly light is playing over the head in a mystic lightning flash of glory.'

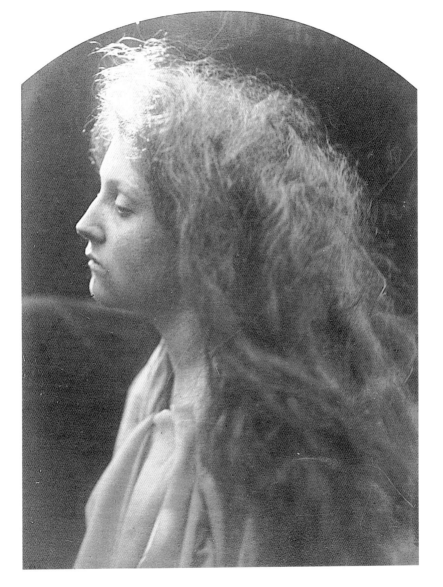

Cupid's Pencil of Light, 1870. The tight cropping at the left suggests that Cupid's wings are outside the camera's range. Cupid touches his pencil to a glass photographic negative that he holds at an angle to reflect the light streaming down from the heavens. Perhaps this is meant as an allegory of photography as a union of love and light.

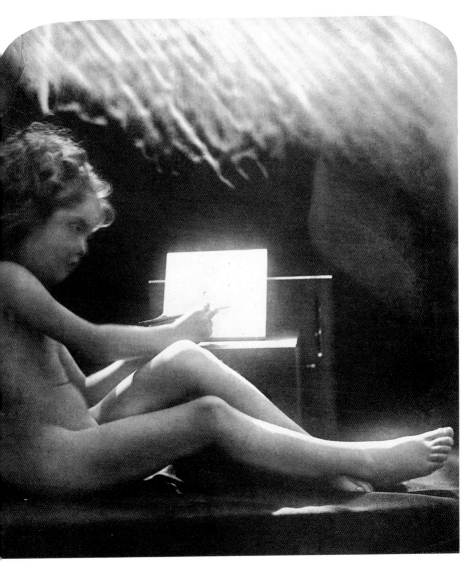

May Prinsep Writing Letter, 1870. In the autumn of 1870, Cameron took over a dozen photographs of May Prinsep, niece of her sister, Sara. This image, evenly focused and lit, with Prinsep in contemporary dress, seated at a table or desk, is typical of these works, which may have been intended as a series on the daily activities of a young woman.

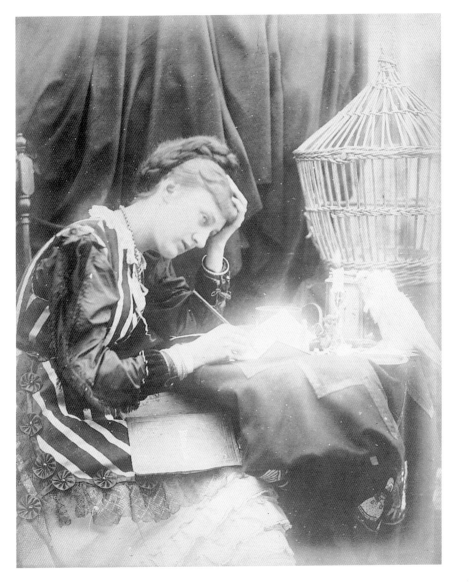

Julia Jackson Duckworth, 1872. Julia Jackson's husband died suddenly in 1870 after only three years of marriage, leaving her a 24-year-old widow with three young children. Cameron photographed her several times in 1872. Six years later, Jackson married Leslie Stephen, essayist and editor of the *Dictionary of National Biography*. The painter Vanessa Bell and novelist Virginia Woolf were the daughters of this marriage. Woolf based the character of Mrs Ramsey in her novel *To the Lighthouse* (1927) on her mother, who died in 1895.

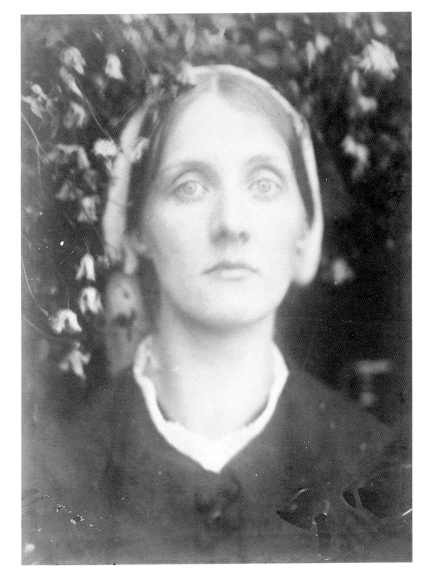

Pomona, 1872. Alice Liddell (1852–1934), who as a girl was the inspiration for Lewis Carroll's *Alice's Adventures in Wonderland* (1865), poses as a young adult for Cameron as the Roman mythological divinity of trees and nature's fecundity. One arm is akimbo, and she looks directly at the viewer, as if she declined to be entirely enveloped by the flowers and plants that surround her decorate her hair and dress, and are held in her extended hand.

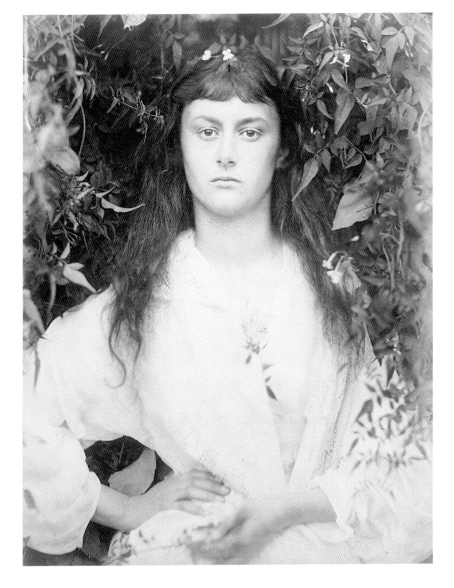

Florence Fisher, 1872. Cameron's low point of view in this photograph of her young great-niece portrays a solemn presence that appears to be neither that of a child, nor of a woman. Florence holds a rose in one hand and her dress slips off her shoulder as she shifts her pose. The suggestiveness of her gesture is almost absorbed, however, by the weight of her arm across her body, held at the same angle as her face, and the impassive expression of her eyes.

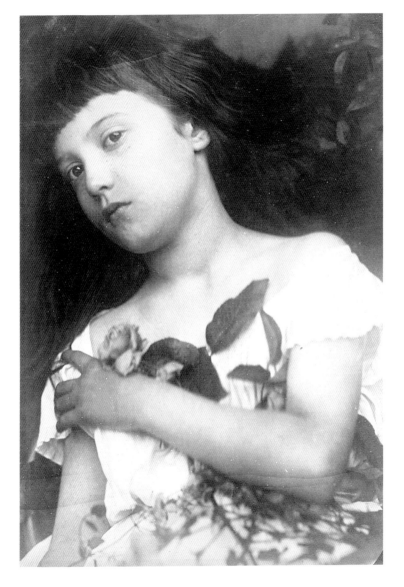

Vivien and Merlin, 1874. The sorceress Vivien seduces Merlin, King Arthur' great ally, into relinquishing a charm that she will use to imprison Merlin in a old oak tree. The contrast between the aged face of the seated Merlin an Vivien's determined look as she moves onto his lap prefigures her success. Sh weaves her fingers into Merlin's beard, while his hand – at the same level grasps at the arm of his chair but does not push her away.

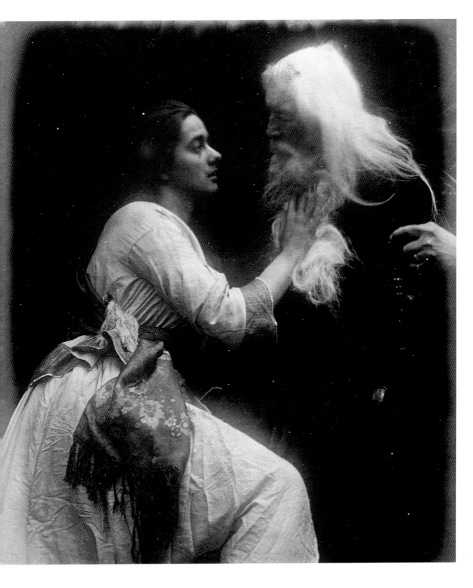

The Passing of Arthur, 1874. The viewer stands at the shore with Sir Bedivere watching as the wounded King Arthur is carried away from Camelot in the care of three queens and their dark-clothed attendants. Cameron's composition for this photograph is indebted to the wood-engraving of the scene by Daniel Maclise in the famous Moxon edition of Tennyson's *Poems* (1857). Cameron achieved the effect of water and mist by combining folded fabric with painted shapes on the negative, and painted a moon in the upper left of the image.

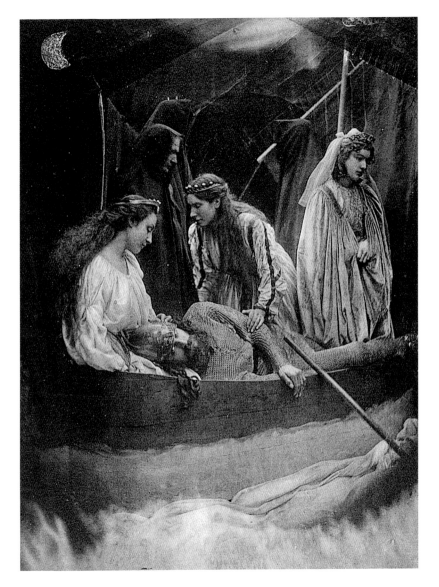

Maud, The Passion Flower at the Gate, 1875. Mary Hillier portrays a sombre Maud, wreathed in the vines of the passion flower. Cameron inscribed lines of a famous song from the Tennyson monodrama 'Maud' (1855) on copies of this print, 'There has fallen a splended tear /From the passion-flower at the gate /She is coming, my dove, my dear; /She is coming, my life, my fate.'

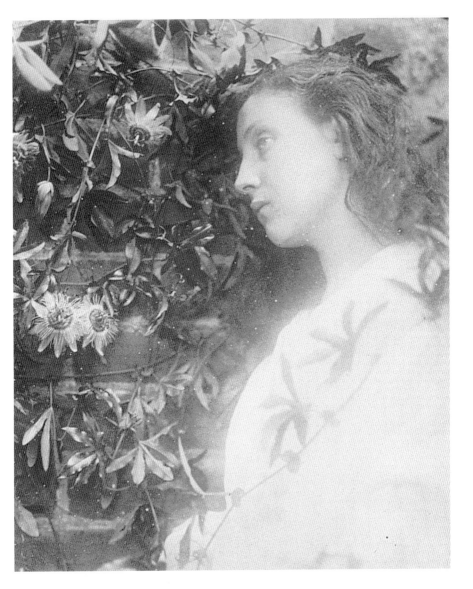

A Group of Kalutara Peasants, 1878. Cameron inscribed this photograph, 'the girl being twelve years of age and the old man saying he is her father and stating himself to be one hundred years of age', but posed the models in a courtship scene. A young man and woman hold hands and a flower, while an older man stands at her other side. In an example of the sexual double standards of the colonialist, Cameron photographed bare-chested men, which she had never done in England.

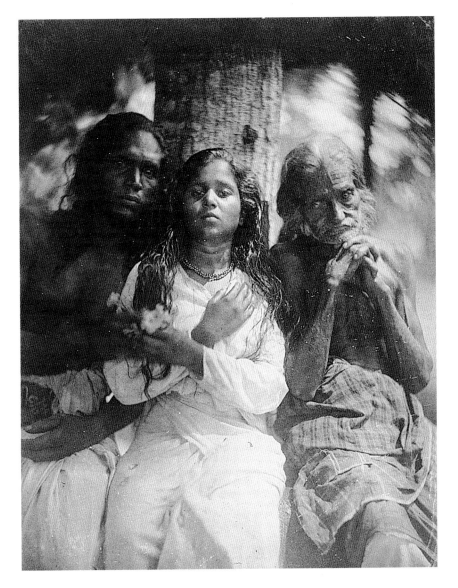

Ceylonese Men, Woman and a Child, c.1876–8. Cameron used an unusually low camera position to create this distinctive image in which the models look down at the camera. While she may have used this position to bring all of the models' looks in a single direction, their active engagement with the camera also conveys authority. While standing face-front in a line before the camera often conveys a quality of passivity to sitters, the models in this photograph are quietly imposing.

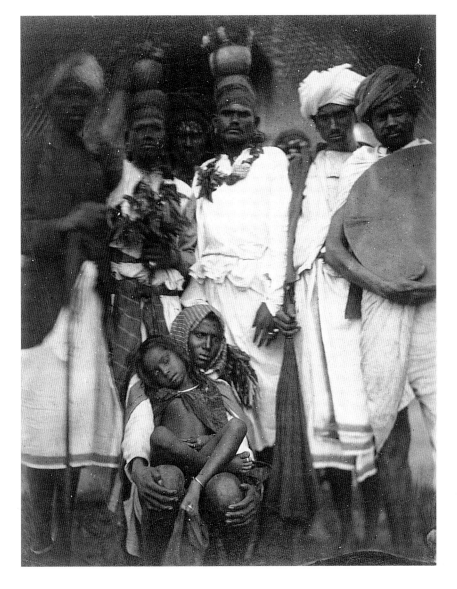

1815 Born Julia Margaret Pattle, 11 June, Calcutta, India, daughter of James and Adeline de l'Etang Pattle. One of ten children.

1818–1835 Travels with family to Europe. Extended stay with her maternal grandmother in Versailles, France.

1836 Meets future husband, widower Charles Hay Cameron (1795–1880), and lifetime friend, John Herschel, visiting the Cape of Good Hope, South Africa, 1835.

1838 In Calcutta, marries Charles Hay Cameron, member of the Indian Law Commission, and first legal member of the Supreme Council of India.

1839 Birth of first child, Julia Hay; four more children born while she lives in India.

1846 Charles Cameron retires and the family moves to England.

1847 Publishes translation of Gottfried Burger's *Lenore* with illustrations by Daniel Maclise.

1850 In January her younger sister, Sara Prinsep, and family move into Little Holland House, London. Sara conducts famous artistic salon where Julia is a frequent guest. Begins important friendships with Alfred and Emily Tennyson, Henry and Alice Taylor.

1852 Youngest child, Henry Herschel Hay, born.

1860 Buys property adjacent to Tennyson's home, Farringford, in Freshwater, Isle of Wight. Names her home Dimbola after the Cameron family coffee estate in Ceylon (now Sri Lanka).

1864 Begins her photographic work in January. Gives an album of her earliest photographs to George Watts in late February. By end May, registers ten photographs for government copyright protection. Exhibits work at the annual exhibitions of the Photographic Society of London and Photographic Society of Scotland. Becomes a member of both organizations.

1865 In January, presents *Fruits of the Spirit* to the British Museum. The South Kensington Museum (now the Victoria and Albert Museum) purchases twenty of her photographs in June. Photographs go on sale at Colnaghi and Company, London, in July and in November she holds what is described as her 'first exhibition' in rooms above the French Gallery, Pall Mall, London. Work is featured in photographic exhibitions in Berlin, Dublin and London; wins a medal in Berlin and an Honourable Mention in Dublin. Begins experimenting with larger negative format (11 x 15 inch).

866–1877 Contributes to photographic exhibitions in London, Isle of Wight and the Universal Exhibition in Paris.

1868 January–February, one-person exhibition at German Gallery, London.

869–1872 Exhibits in photographic exhibitions in the Netherlands (1869), London (1870) and at the London International Exhibitions (1871, 1872).

1873 Exhibits at the Universal Exhibition, Vienna, and the International Exhibition, London. Her only daughter, Julia Norman, dies in October.

1874 Begins work on photographic illustrations to Tennyson's *Idylls of the King* in October.

1875 Publishes *Illustrations to Tennyson's Idylls of the King and Other Poems* as a gift book. Moves back to Ceylon in October.

1876 Exhibits at International Exhibition, Philadelphia, USA, and at photographic societies in London and Edinburgh.

1878 Visits England for the last time in April.

1879 Dies in Ceylon on 26 January after a short illness.

Photography is the visual medium of the modern world. As a means of recording, and as an art form in its own right, it pervades our lives and shapes our perceptions.

55 is a new series of beautifully produced, pocket-sized books that acknowledge and celebrate all styles and all aspects of photography.

Just as Penguin books found a new market for fiction in the 1930s, so, at the start of a new century, Phaidon **55**s, accessible to everyone, will reach a new, visually aware contemporary audience. Each volume of 128 pages focuses on the life's work of an individual master and contains an informative introduction and 55 key works accompanied by extended captions.

As part of an ongoing program, each **55** offers a story of modern life.

Julia Margaret Cameron (1815–79) was almost fifty – and practically self-taught – when she took up photography seriously, yet she produced some of the most innovative and visually striking portraits of the time. Her novel use of lighting and focus transformed portraiture and helped secure the acceptance of photography as an expressive art.

Joanne Lukitsh is a professor of Art History at the Massachusetts College of Art in Boston. She recently received a US Endowment for the Humanities award for her research on Julia Margaret Cameron.

Phaidon Press Limited
Regent's Wharf
All Saints Street
London N1 9PA

Phaidon Press Inc.
180 Varick Street
New York NY 10014

www.phaidon.com

First published 2001
©2001 Phaidon Press Limited

ISBN 0 7148 4017 3

Designed by Julia Hasting
Printed in Hong Kong

Photographs by permission of: The Royal Photographic Society; The V&A Picture Library; The National Museum of Photography, Film & Television/Science and Industry; Tennyson Research Centre, Lincoln, by permission of Lincolnshire County Council; Jane and Michael Wilson Collection.